FLOWERS

THE WATERCOLOR ART PAD

RACHEL PEDDER-SMITH

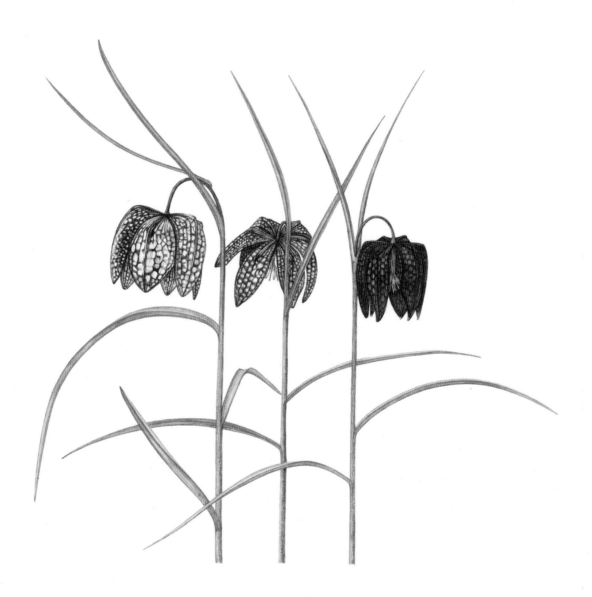

St. Martin's Griffin
New York

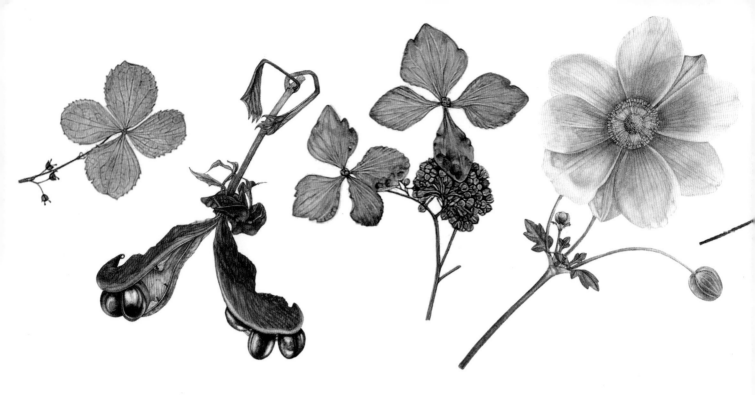

FLOWERS: THE WATERCOLOR ART PAD.
© 2017 Quarto Publishing plc

www.stmartins.com

ISBN 9781250146472 (trade paperback)

Our books may be purchased in bulk for promotional, educational, or business use. Please contact your local bookseller or the Macmillan Corporate and Premium Sales Department at 1-800-221-7945, extension 5442, or by e-mail at MacmillanSpecialMarkets@macmillan.com.

First U.S. Edition: September 2017

10 9 8 7 6 5

This book was conceived, designed and produced by
The Bright Press, an imprint of the Quarto Group
The Old Brewery, 6 Blundell Street,
London N7 9BH, United Kingdom.
T (0)20 7700 6700 www.QuartoKnows.com
WFAP

Designers: Michelle Rowlandson, Anna Gatt, Natalie Clay, Marie Boulanger
Project Editors: Diana Craig, Leah Feltham
Editorial Director: Emma Bastow
Publisher: Mark Searle

All illustrations by Rachel Pedder-Smith

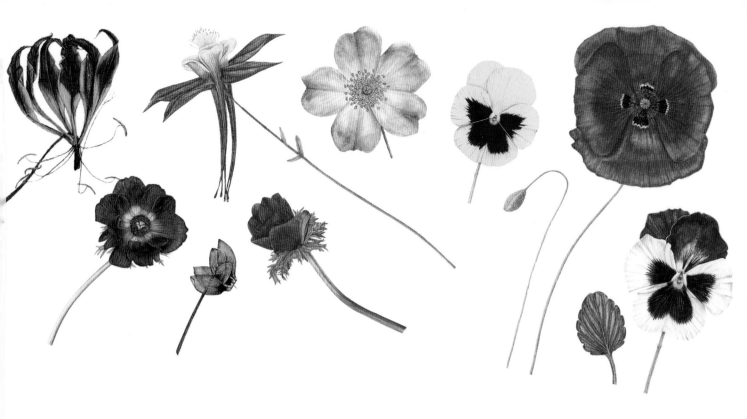

CONTENTS

GETTING STARTED

Explore tools and techniques that will help you achieve professional results.

TUTORIALS

Follow four guided tutorials to understand the painting process.

FLOWER GALLERY 16

A gallery of botanical paintings by Rachel Pedder-Smith. Use these pages as your guide to creating beautiful watercolor paintings.

Get Painting
Turn to the watercolor paper after page 24 and pull out a page to get started.

Introduction

I was introduced to watercolor when I was an art student at university. My tutor told me that if I was going to be a natural history illustrator I needed to paint in watercolor. Although I didn't have any formal training in the medium, I started to practice. I have built up a range of techniques solely from trying things out over many years.

Watercolor is the traditional medium for botanical art for a number of reasons. As well as being versatile, it is sensitive, subtle, and well suited to capturing the delicate and sometimes ethereal nature of petals. It can also be applied in layers to create darker tones and heavier forms.

But there are other practical reasons why watercolor is ideal for botanical painting: It's conveniently transportable and dries quickly, so it is easy to use in the field or, as in previous centuries, on voyages of discovery when ships' artists needed to record the exotic plants they saw. My own favorite moment in painting is when the object is drawn out and I use what is called a wet-on-wet technique. Using clean water, I wet the area I want to color, mix my first color wash, drop it onto the damp paper and watch how—as if by magic—the paint spreads to the outer limit of the damp area. This is a magical moment every time, the first step to a new piece of art.

There are 15 of my flower paintings in this book, along with some practical information on materials and techniques. With these to inspire and guide you, I hope you will experience that same feeling of magic that I do, and that you will create your own gorgeous flower paintings in watercolor.

Rachel Pedder-Smith

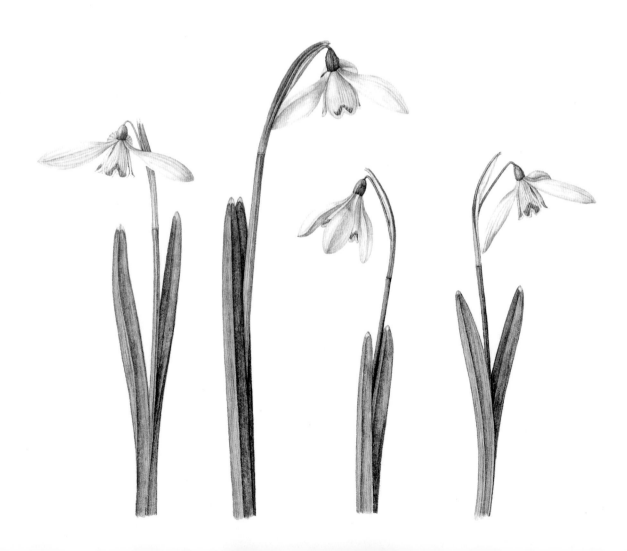

How to use this book

Select a flower
Choose the flower you want to paint from the outlines printed on the watercolor paper at the back of the book.

Pull out the sheet
Remove the watercolor sheet by pressing down on the opposite page and pulling firmly but carefully. Secure it to a surface by taping it down with masking tape along all four edges. This will help to prevent the paper buckling when wet.

Refer to the Flower Gallery
As you paint, refer to the original artwork and the recommended color palettes in the Flower Gallery on pages 16–24. Each color used in this book has been given a number—see the complete palette on page 6.

Advice for beginners
For guidance on how to get started with watercolors, turn to page 6. As well as describing the equipment you'll need, it shows the full palette of 24 colors used in this book, with their names and key numbers. Before you embark on your first project, using spare paper, practice the watercolor techniques described on page 7 and try the tutorials on the pages that follow.

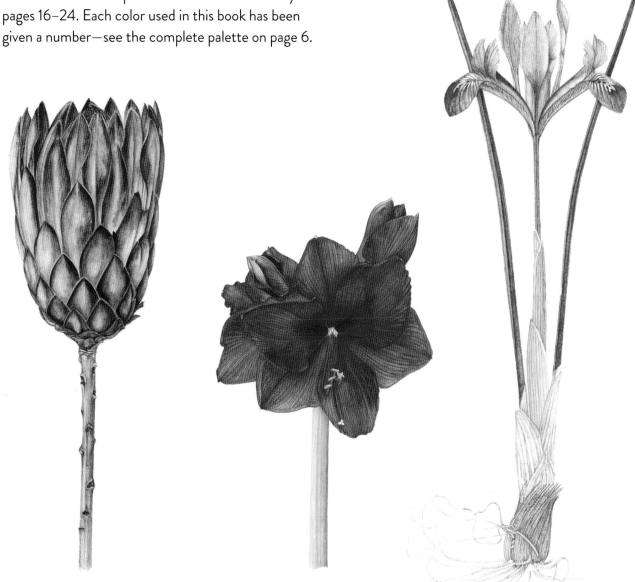

Getting started

Flower painter's toolkit

Before you embark on your adventure as a watercolor flower painter, you'll need to have a basic kit. Listed here are the essential tools and materials you'll need to recreate the botanical paintings in this book.

Paints

For rich, jewel-like color, it's really important to use professional-quality paints as these contain more pigment. You can buy them in tubes or pans (little blocks); pans have the advantage of being really easy and quick to work with. The paintings in this book require 24 different colors—you can see them listed on the right. In some cases you may have to combine many colors to create the right one for a particular petal.

Palette

The metal leaves of a travel paint set make a very handy palette, and it's a good idea to never wash the colors off—they often come in very useful on another day. If you start to run short of space, just clean off a small section with a tissue. If you don't have a purpose-made palette, you could use a white ceramic plate instead.

Brushes

You'll need four sizes of paintbrush: a size 6, a size 4, a size 000, and a size 0000. These are a synthetic and sable mix and keep their fine point for longer than pure sable; they are also more reasonably priced. The largest brush is ideal for the initial washes and the smaller brushes can be used for all of the detail, reserving the size 0000 for fine lines.

Paper towels

It is essential to have a tissue or paper towels on hand as you paint. You'll find you use them frequently, whether to wipe color off the brush when using a dry-brush technique, to create highlights by lifting color off the paper, or to remove color immediately if you make a mistake.

Masking fluid

This can be useful for masking out small, precise areas that you want to retain as highlights. It comes in bottles or in a handy pen form that allows you to apply the fluid directly via the nib. If applying with a brush, dip the brush into a detergent solution first and wipe off the excess moisture with paper towels before dipping it into the fluid, to prevent clogging. Allow the fluid to dry completely before painting over it.

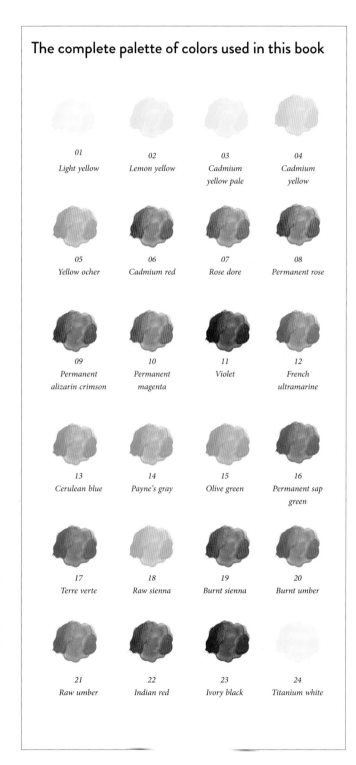

The complete palette of colors used in this book

01 Light yellow	*02* Lemon yellow	*03* Cadmium yellow pale	*04* Cadmium yellow
05 Yellow ocher	*06* Cadmium red	*07* Rose dore	*08* Permanent rose
09 Permanent alizarin crimson	*10* Permanent magenta	*11* Violet	*12* French ultramarine
13 Cerulean blue	*14* Payne's gray	*15* Olive green	*16* Permanent sap green
17 Terre verte	*18* Raw sienna	*19* Burnt sienna	*20* Burnt umber
21 Raw umber	*22* Indian red	*23* Ivory black	*24* Titanium white

Watercolor terms and techniques

There are a few key watercolor techniques that you'll use again and again on the different projects in this book. Try them out on spare paper first so that you really get to know how to use them.

Making a wash

Watercolor paint needs to be mixed with water to liquefy it. The more water you add, the thinner the mixture will be and the lighter the color. This combination of paint and water is known as a "wash." Dip your brush into water and then load it with your desired color. Use your palette to adjust the balance of color to water or to mix with other colors.

Painting wet-on-wet

The wet-on-wet technique involves painting onto wet paper or paint. Use this technique only when applying the first wash. First, wet the paper using a large brush and clean water. Take it only as far as you want the color to spread and leave highlighted areas dry. Now apply the first wash of color with a large brush and watch the paint flow evenly over the wet surface to the edge, where it will stop, leaving a distinct line or watermark. You can add in different colors while still wet.

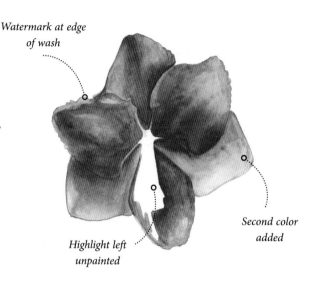

Watermark at edge of wash

Second color added

Highlight left unpainted

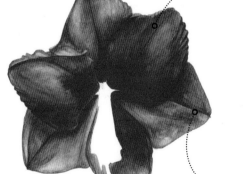

Building up color

Petals loosely defined

Painting wet-on-dry

For this technique, you wait for the previous layer of paint to dry before applying the next. Use this method to build up the color after applying the first wash. Working on a dry surface gives greater control over the spread of the paint. Use a large brush to apply the wash to the dry paper in certain areas, building up the color, shading, and giving loose definition to the petals.

Using a dry-brush

This method allows you to add fine detail to your painting with a small brush—using the brush almost like a pencil. Dip the brush into the paint regularly but wipe it carefully on some paper towels to remove any excess color before touching the paper. Use the dry-brush technique to build up texture with fine lines and tiny vein details.

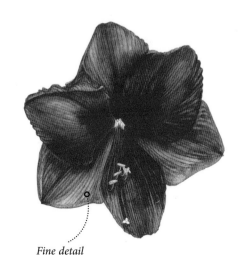

Fine detail

How to paint a flower in watercolor

When painting a flower in watercolor, start by building up the base layers using paint mixed with lots of water and applied with a large brush. Once this looks like fleshy petals, add the fine detail using a dry-brush technique. Finally, add richness and depth with further washes of color. Here, the process is demonstrated with a tulip but you can use the same techniques for all the flowers in this book.

(1) Working wet-on-wet and using your size 6 brush, dampen the paper up to the outer outline of the flower. Mix together a wash of rose dore, permanent alizarin crimson, and permanent rose. Using the same brush, start to flow the color in over the flower petals. Make sure that your brushstrokes follow the form of the petals and "reserve" the light parts of the petals (leaving them completely white). Here the images show a flower before painting, with one petal painted, and with a complete first wash.

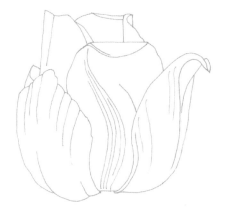 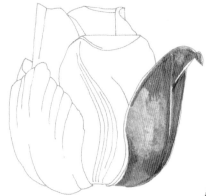 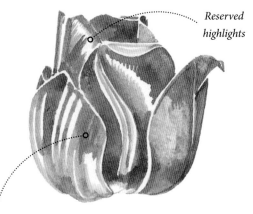

Reserved highlights

Brushstrokes follow the shape of the petal

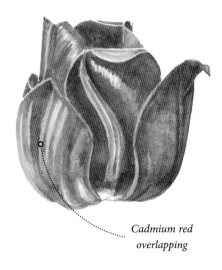

Cadmium red overlapping

(2) Now start to build up the color by adding further washes over the whole flower, softening the highlights with a little color. Work wet-on-dry and wait for each wash to dry before adding another. Using the same wash as before will deepen the tones; using a different wash will alter the original color or intensify areas of light and dark. Be careful not to lose the highlights completely. Here, a cadmium red wash enriches the redder parts of the tulip and softens the pink tones.

Dry-brushed detail

(3) Using a size 000 brush and the dry-brush technique, carefully pick up some of the original wash and stroke this color on to accentuate some of the deeper ridges in the petals. Always have a paper towel ready to dab any areas with too much color.

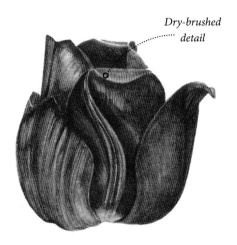

(4) Rinse your size 6 brush in clean water and dab it with a paper towel so it is just damp. Gently brush it across any color that is too bold, or any highlights that are too white, to soften them. Take care not to lose the highlights completely.

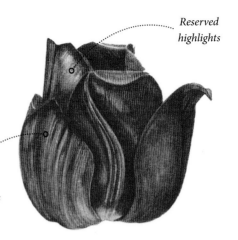

Reserved highlights

Softened highlights

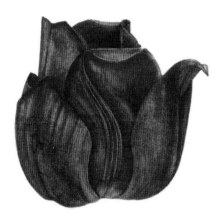

(5) To make the petals "glow," continue to build up the color with further washes. Use darker tones for the shadows, but take care to maintain the highlights. A wash of permanent alizarin crimson, permanent rose, cadmium red, and violet was used to darken the shadows on this tulip.

(6) If you lose highlights or need to accentuate them, carefully dab clean water onto those parts of the painting to loosen the color, then lift it off with a paper towel. Apply any final washes to add depth or brighten the color. Use small dry-brush lines to add finer details, such as the texture of the petal.

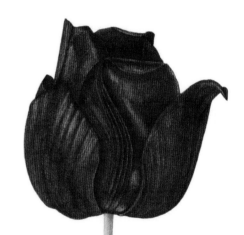

Dry-brushed lines to add detail

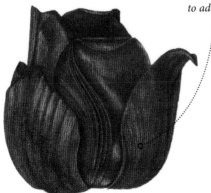

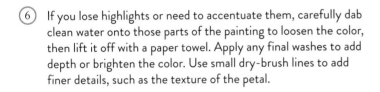

How to paint stems

To show that stems have a three-dimensional form, make one side much darker than the other—on this tulip stem, the dark side is on the right. Payne's gray is a useful color for the shadow on stems. Pale washes with a hint of lemon yellow work well on the lighter side.

How to paint white flowers

White flowers are one of the trickiest things to paint as it is very easy to overdo the shadow and make the flower look gray rather than white. It's best to start with the minimum amount of color and build up slowly. Here, a calla lily is used to demonstrate the process but you can paint any white flower in a similar way.

① Start by lightly painting in the shadows to suggest the shape of the flower; for example, where a petal bends downward, where part of a petal overlaps another, or where there are any ridges in the petals. Use a very diluted wash of Payne's gray and work with a light touch—the shading should be very delicate. Here the images show the flowers before painting and with the initial delicate wash that suggests shadows.

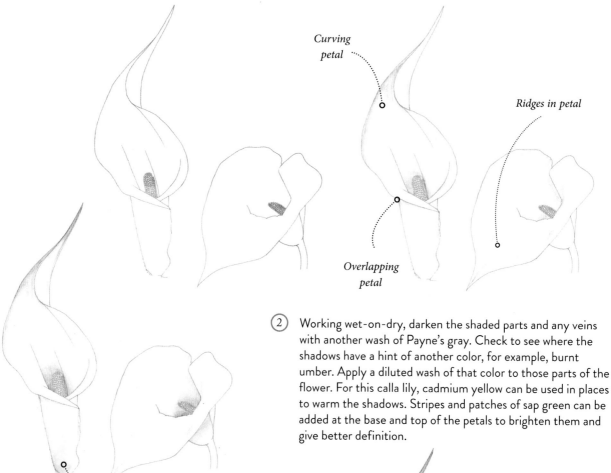

Curving petal

Ridges in petal

Overlapping petal

② Working wet-on-dry, darken the shaded parts and any veins with another wash of Payne's gray. Check to see where the shadows have a hint of another color, for example, burnt umber. Apply a diluted wash of that color to those parts of the flower. For this calla lily, cadmium yellow can be used in places to warm the shadows. Stripes and patches of sap green can be added at the base and top of the petals to brighten them and give better definition.

Color added to shadow

③ Use the Payne's gray wash to darken the shadows further. You may need to paint a crisp line between a shaded and a white area to define the shape, as here, where the flower forms a tube and one part overlaps another. Where a petal rolls under and is partly in shadow, create a more gentle edge by sweeping a large, clean damp brush over the shadow to soften it. Build up the vein details with the Payne's gray.

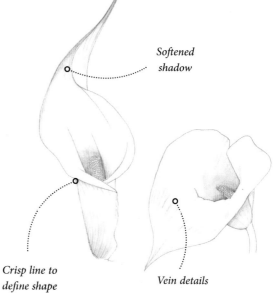

Softened shadow

Crisp line to define shape

Vein details

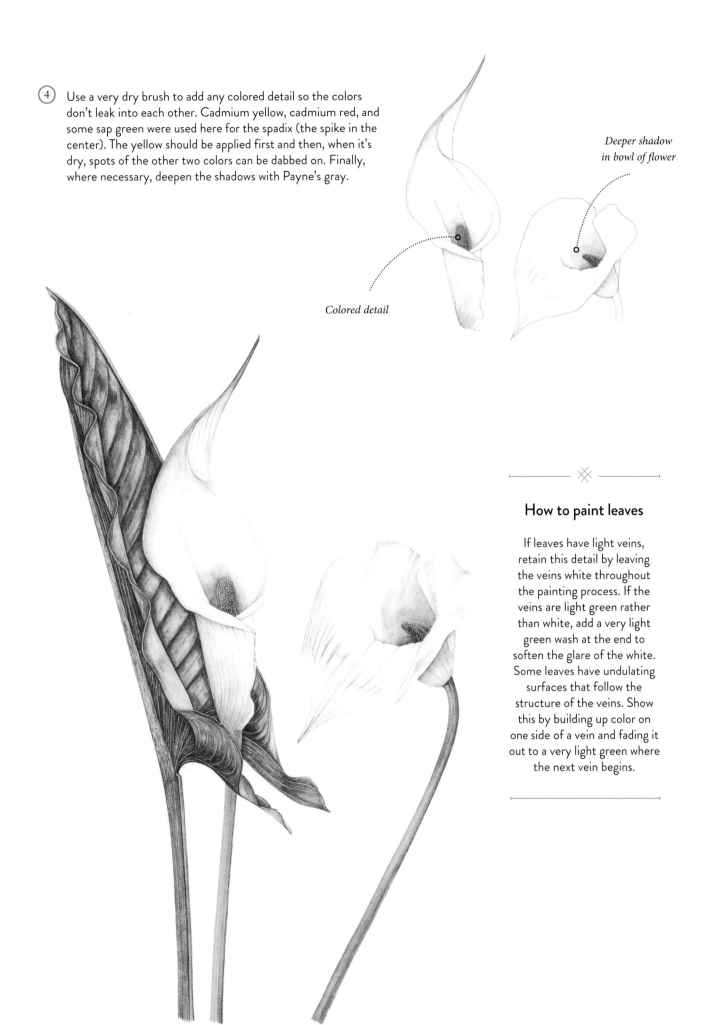

④ Use a very dry brush to add any colored detail so the colors don't leak into each other. Cadmium yellow, cadmium red, and some sap green were used here for the spadix (the spike in the center). The yellow should be applied first and then, when it's dry, spots of the other two colors can be dabbed on. Finally, where necessary, deepen the shadows with Payne's gray.

Deeper shadow in bowl of flower

Colored detail

How to paint leaves

If leaves have light veins, retain this detail by leaving the veins white throughout the painting process. If the veins are light green rather than white, add a very light green wash at the end to soften the glare of the white. Some leaves have undulating surfaces that follow the structure of the veins. Show this by building up color on one side of a vein and fading it out to a very light green where the next vein begins.

How to paint pattern and texture

Patterns are built up slowly, using dabs of paint in different colors. If the pattern covers the whole surface it is important to indicate light and dark areas from the beginning, so that these are maintained throughout the darkening of the pattern. Although a gourd is used to illustrate this process here, you can paint the fritillaries (see page 21 in Flower Gallery) in the same way but using different colors.

(1) Working wet-on-dry, apply the first color; begin with a mix of sap green, French ultramarine, Payne's gray, and alizarin crimson. Apply dabs of this green in bands, making boxy, rectangular shapes. You can use a size 6 brush to block in this first color more quickly, but take care not to lose the gaps in the pattern. When the green is dry, brush a light yellow wash into the spaces. Here the images show a gourd before painting; with the first green bands painted; and with a light yellow wash worked into the spaces.

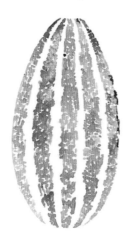

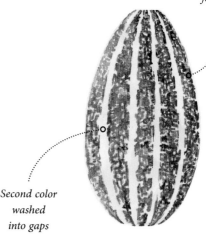

Dabs of first color

Second color washed into gaps

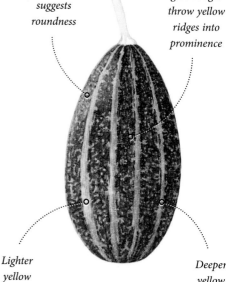

(2) For finer detail, switch to a size 000 brush. For this gourd, use the same green wash as used in step 1 to add darker details to the right-hand side. Apply a cadmium yellow and cadmium red mix to the yellow areas on the right, and a lighter cadmium yellow wash on the left, leaving small gaps to show the paler yellow underneath. This difference in tone between right and left suggests the gourd's rounded, three-dimensional shape.

Lighter surface on left

Darker surface on right

Yellow gaps showing through

Soft highlight suggests roundness

Darkened green edges throw yellow ridges into prominence

(3) Now start to strengthen the pattern; use the same green wash, with a touch of violet, to darken the stripes and define their edges, especially those on the right—this throws the yellow ridges into greater relief. Apply the cadmium yellow wash to the yellow parts on the left and the cadmium yellow and red mix to the yellow areas on the right, then dab yellow ocher into some gaps in the green stripes. For the stem, use a very pale wash of sap green and light yellow. For the soft highlight on the top left, dampen the color and then gently lift some of it off with a paper towel.

Lighter yellow

Deeper yellow

4. Now, concentrate on the stem. Using the previous wash, with added yellow ocher, paint in the ridges and shadows on the stem. Use violet for the shadow on the right-hand side and for the ridges. Then, when the paint is dry, add a wash of light yellow over the whole stem to soften some of the shadows.

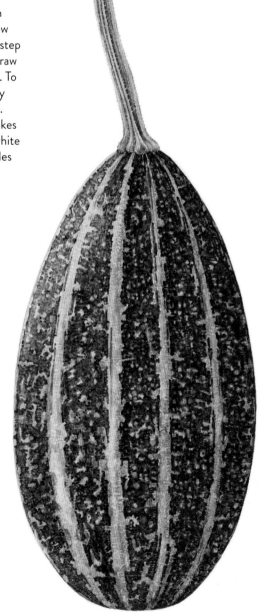

Shadow and ridges on right of stem

Stem darkened and defined

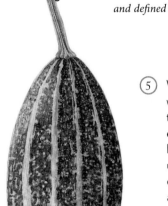

5. When the previous washes are dry, darken the grooves and shadow established in the last step by brushing a wash of raw umber down the stem. To darken it further, apply another wash of violet. To finish, add tiny strokes of very dry titanium white to show the fine prickles on the stem.

⁂

How to paint fine hairs

Some stems and petals look velvety because they are covered with tiny hairs or prickles. To depict these, use a size 0000 brush. Dip the brush into the paint, then wipe the tip carefully before applying it quickly and lightly to the paper to achieve the finest of lines.

How to paint seeds and shiny objects

The secret to convincingly depicting hard and shiny objects is to retain white or very light areas within darker areas of shadow. The white areas suggest the sheen on raised parts of the surface while the contrast between light and dark suggests three-dimensional form. Applying masking fluid can help to protect the essential white patches while you darken the surrounding parts. Peony pods are used here to demonstrate this process.

1. Begin with a reasonably dark wash by mixing ivory black, violet, French ultramarine, and burnt umber and work wet-on-dry for maximum control. Pay careful attention to where the light areas lie and block in the dark color, feathering it out at the edges. It is better to leave more white than too little as you can always darken it if necessary. Here the images show the seeds before painting; with the dark wash blocked in on two pods; and with all pods showing their initial wash.

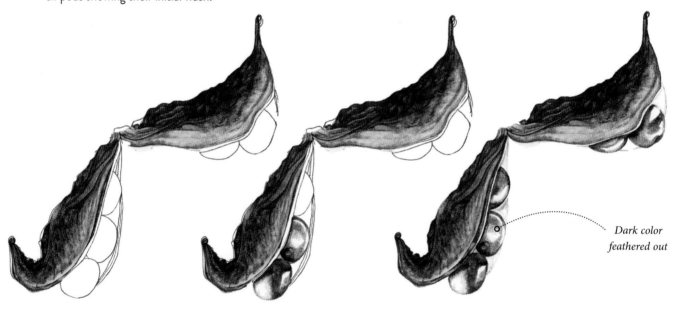

*Dark color
feathered out*

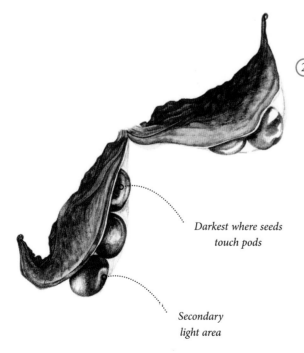

2. Next, darken the wash and apply further layers of color. Concentrate especially on the darkened junctions between seeds and pods, and also check for shadowed areas. By darkening these areas you will make the seed look more three-dimensional. Light can come from more than one direction, so observe carefully and perhaps map out the areas of light using a light pencil line.

*Darkest where seeds
touch pods*

*Secondary
light area*

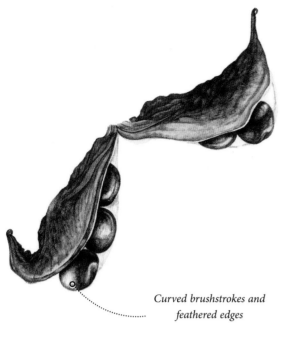

3) Dry-brush on more color, drawing small lines within the shadowy areas to darken the seeds further. Follow the shape of the seeds with curved brushstrokes, feathering the color slightly into the light areas to soften any hard edges. You can use a wet brush to soften hard edges, but avoid this technique when there are very definite white areas—as with these peony seeds—as you can easily lose the pure white.

Curved brushstrokes and feathered edges

4) When you're finished painting, some parts of the seeds will be nearly black while others with have no paint on them at all. The darkest areas of shadow, where the seeds touch the pods, need six or seven washes to complete. If you do lose too much of the white you can lift off the paint by applying clean water and dabbing it off with a paper towel, but you will not get the paper completely back to its original whiteness.

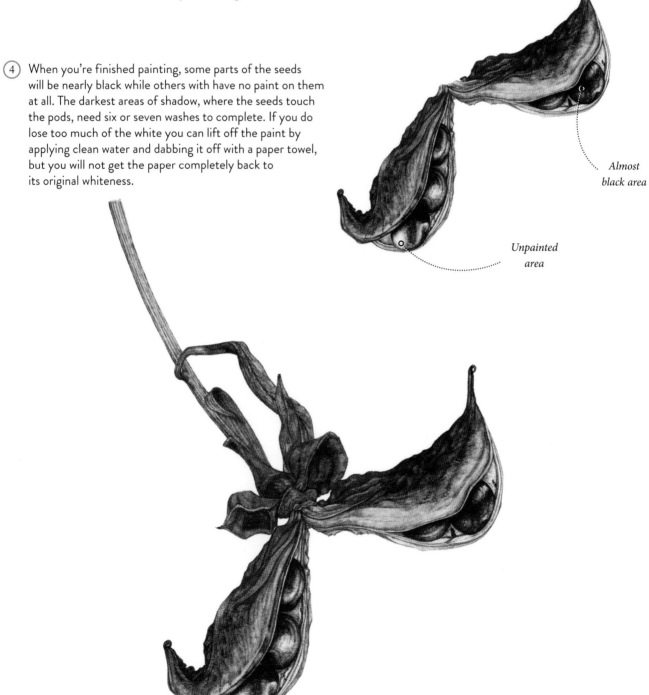

Almost black area

Unpainted area

FLOWER GALLERY

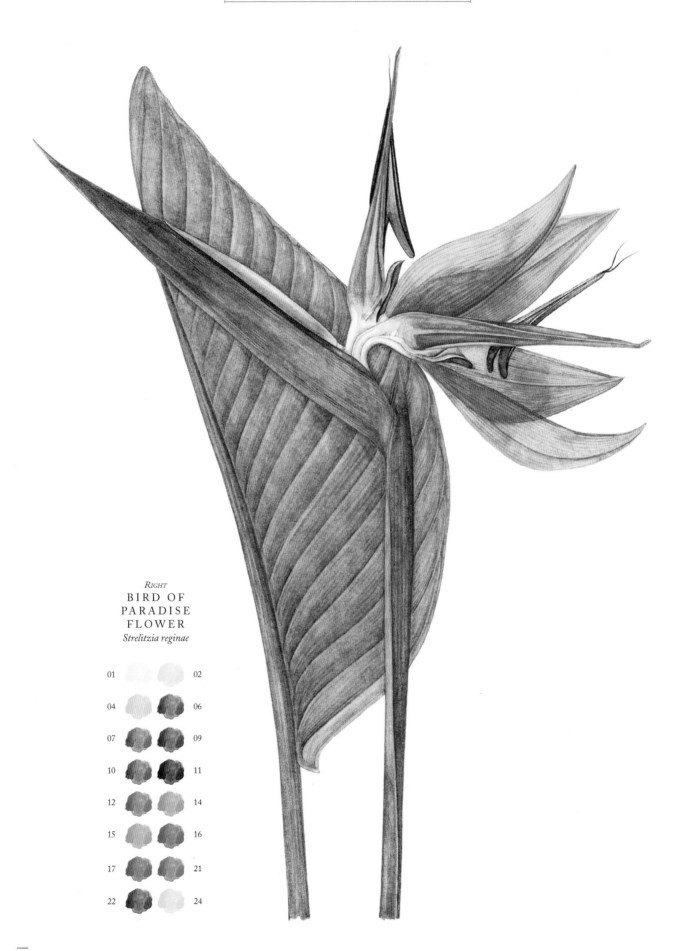

Right
BIRD OF
PARADISE
FLOWER
Strelitzia reginae

01		02
04		06
07		09
10		11
12		14
15		16
17		21
22		24

PANSIES
Viola tricolor var. *hortensis*

01 02
03 04
06 08
09 11
12 14
16 17
19 20

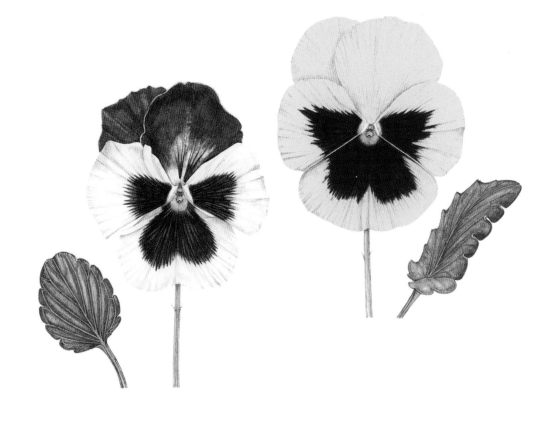

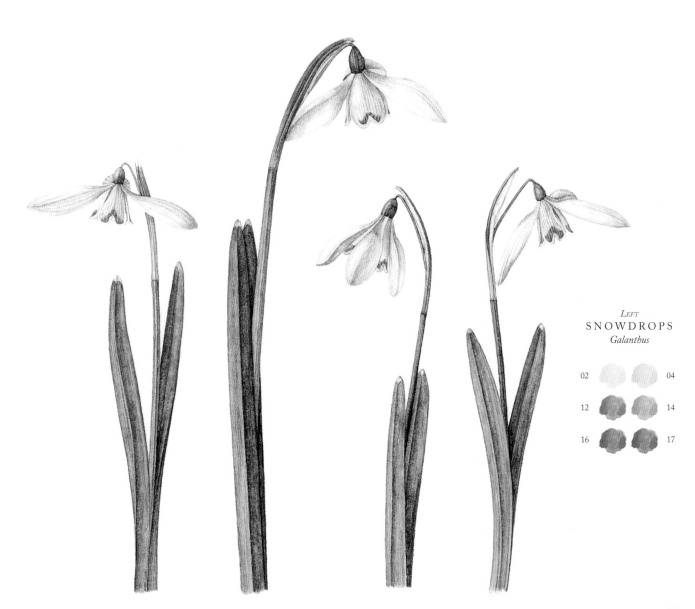

Left

SNOWDROPS
Galanthus

02 04
12 14
16 17

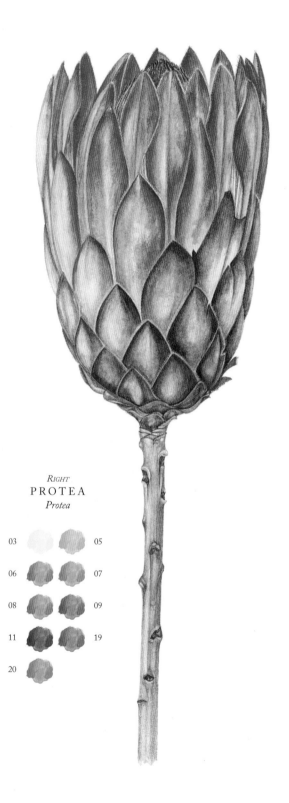

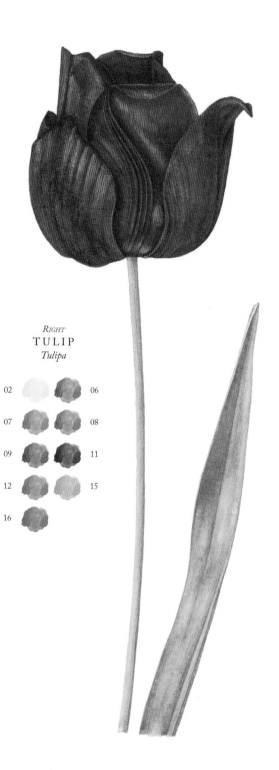

RIGHT
TULIP
Tulipa

02			06
07			08
09			11
12			15
16			

RIGHT
PROTEA
Protea

03			05
06			07
08			09
11			19
20			

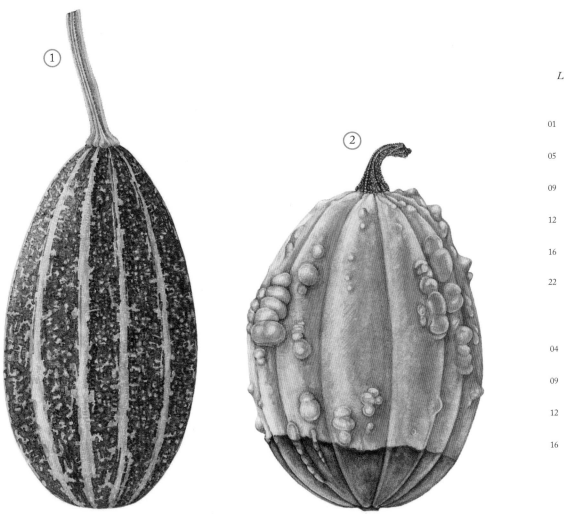

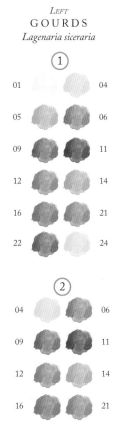

GOURDS
Lagenaria siceraria

1

01			04
05			06
09			11
12			14
16			21
22			24

2

04			06
09			11
12			14
16			21

RIGHT
POPPIES
Papaver somniferum

01			02
04			05
06			09
11			15
16			17
20			22
23			24

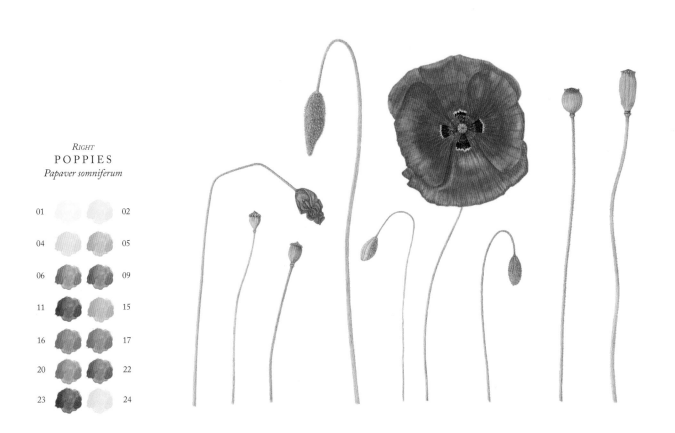

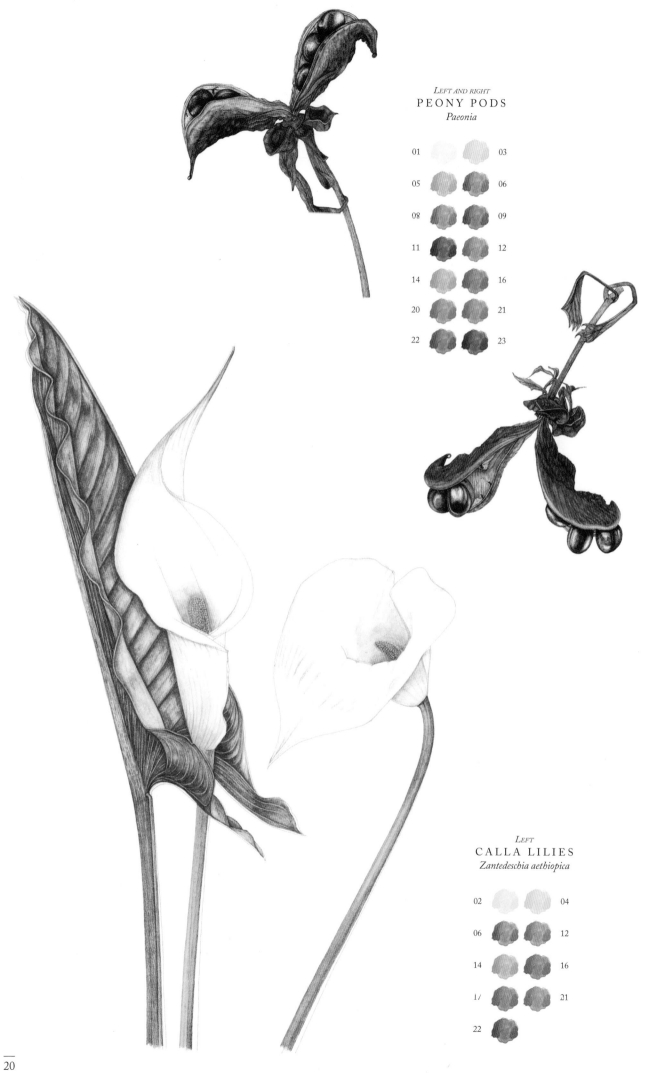

01 03
05 06
08 09
11 12
14 16
20 21
22 23

LEFT
CALLA LILIES
Zantedeschia aethiopica

02 04
06 12
14 16
17 21
22

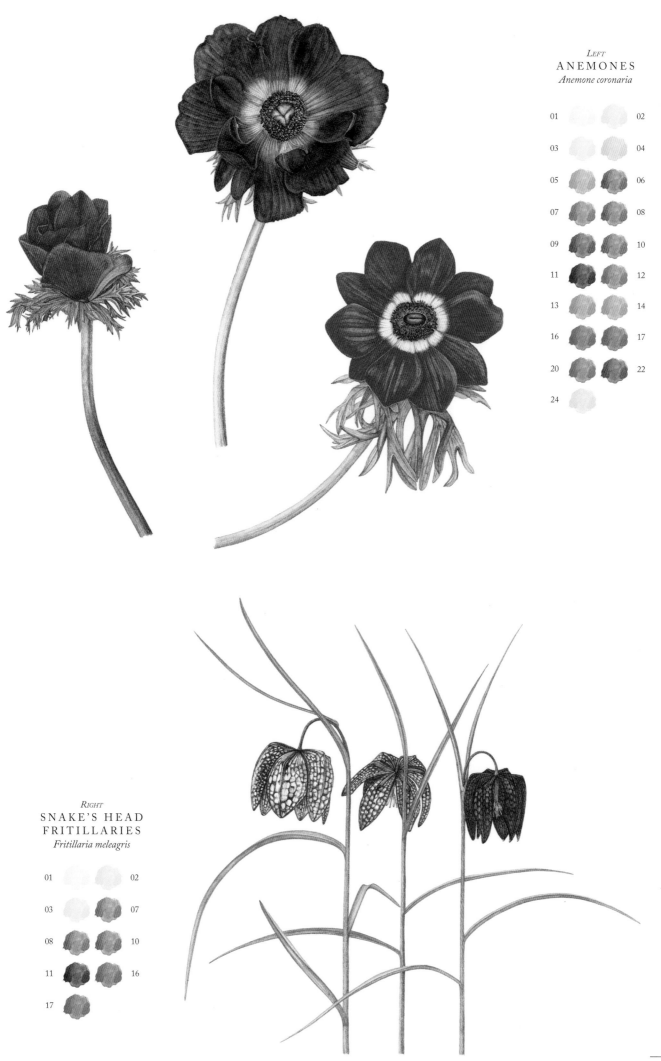

01 02

03 04

05 06

07 08

09 10

11 12

13 14

16 17

20 22

24

01 02

03 07

08 10

11 16

17

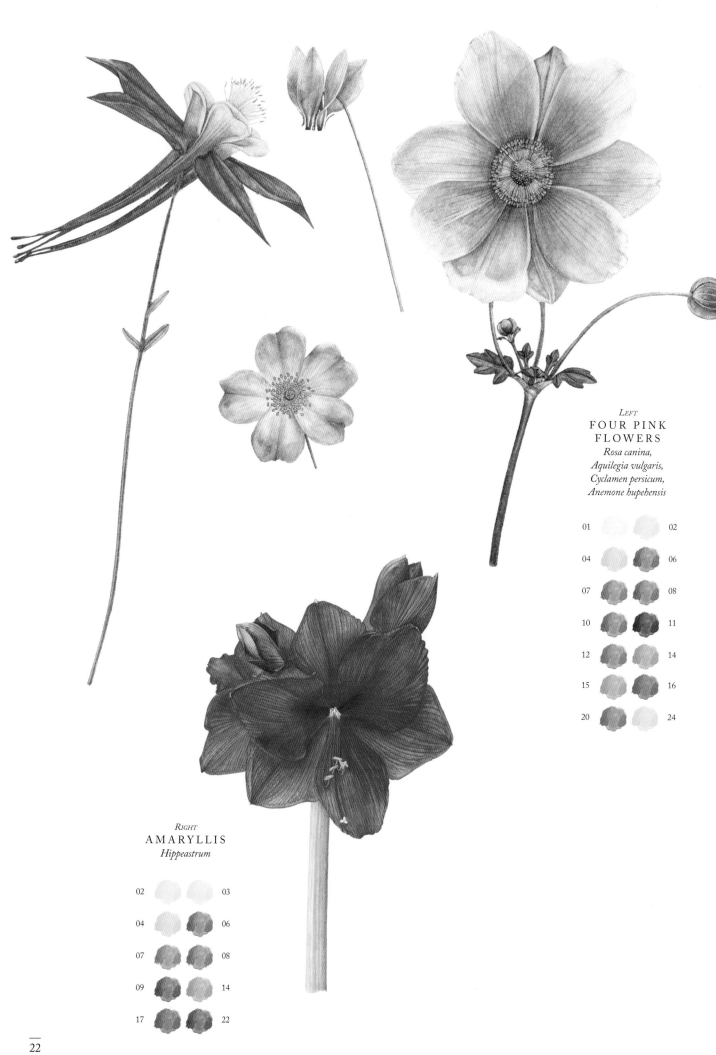

FOUR PINK
FLOWERS
Rosa canina,
Aquilegia vulgaris,
Cyclamen persicum,
Anemone hupehensis

01			02
04			06
07			08
10			11
12			14
15			16
20			24

RIGHT
AMARYLLIS
Hippeastrum

02			03
04			06
07			08
09			14
17			22

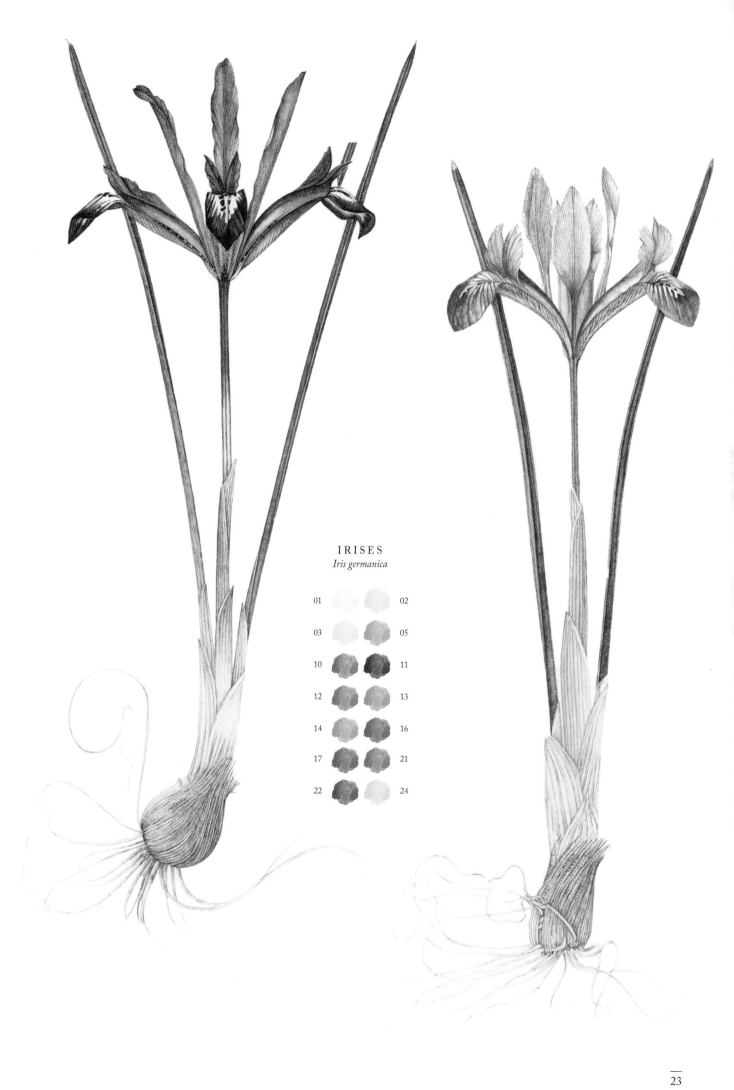

IRISES
Iris germanica

01 02

03 05

10 11

12 13

14 16

17 21

22 24

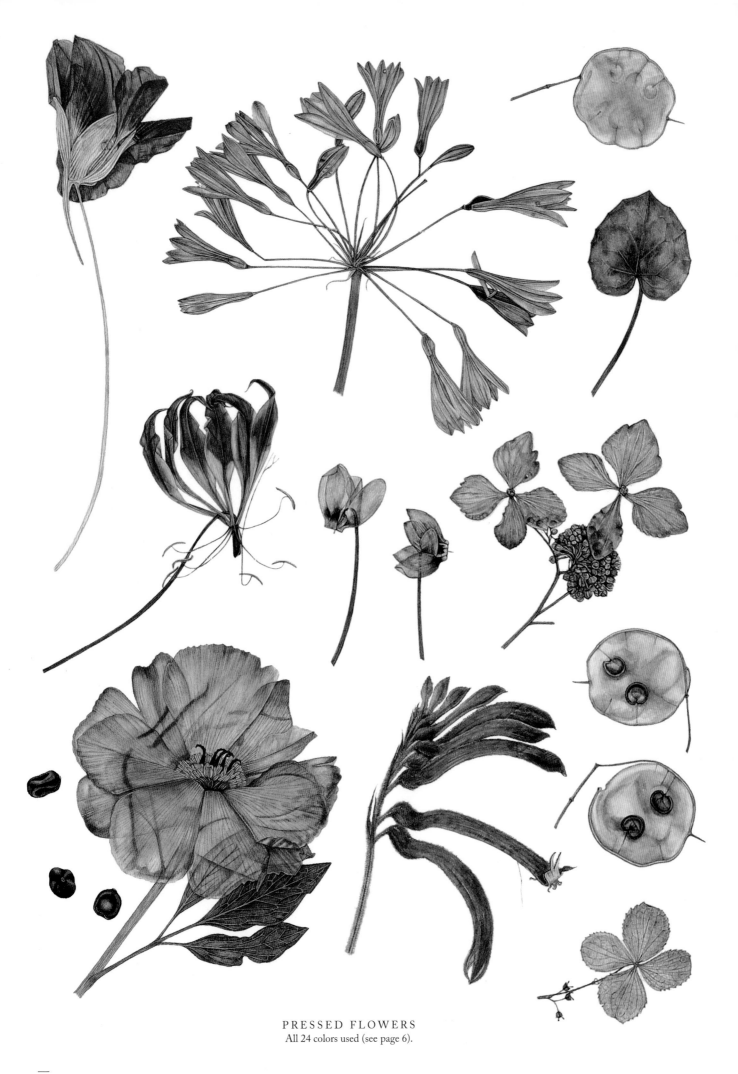

PRESSED FLOWERS
All 24 colors used (see page 6).

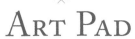

ART PAD

Pull out a sheet of watercolor paper and tape it to a hard surface. Refer to the artworks and color palettes in the Flower Gallery on pages 16–24 as you paint.

BIRD OF PARADISE FLOWER
Strelitzia reginae

PANSIES

Viola tricolor var. hortensis

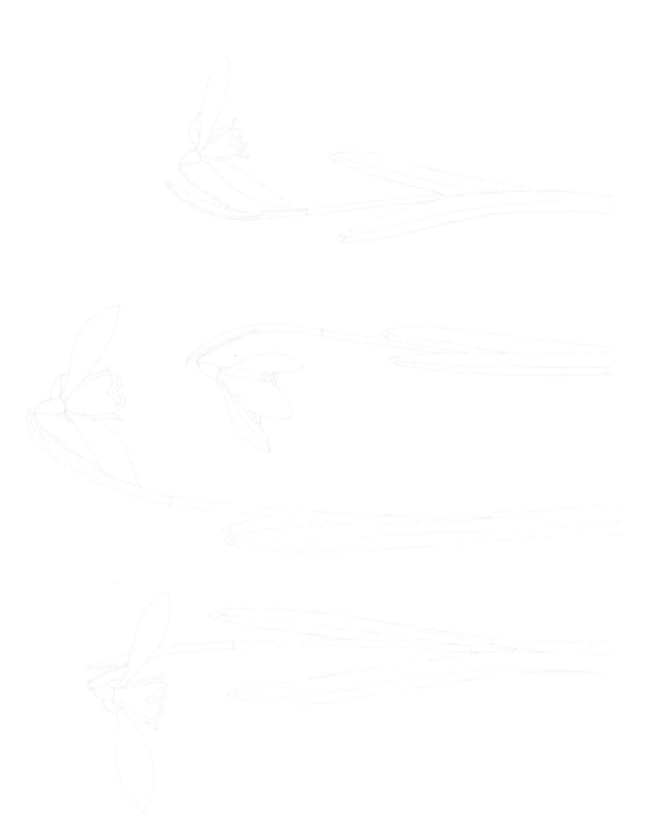

PROTEA
Protea

TULIP
Tulipa

GOURDS
Lagenaria siceraria

POPPIES
Papaver somniferum

PEONY PODS
Paeonia

CALLA LILIES
Zantedeschia aethiopica

ANEMONES
Anemone coronaria

SNAKE'S HEAD FRITILLARIES
Fritillaria meleagris

FOUR PINK FLOWERS
Rosa canina, Aquilegia vulgaris,
Cyclamen persicum,
Anemone hupehensis

AMARYLLIS
Hippeastrum

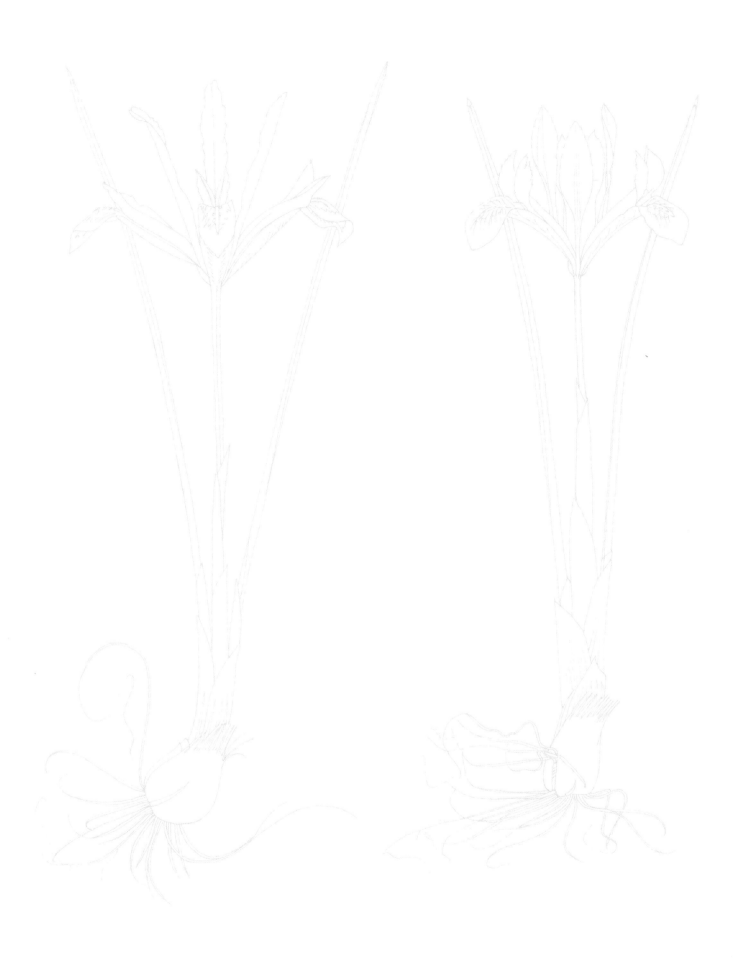

IRISES
Iris germanica

PRESSED FLOWERS